THE WATSON GORDON
LECTURE 2018

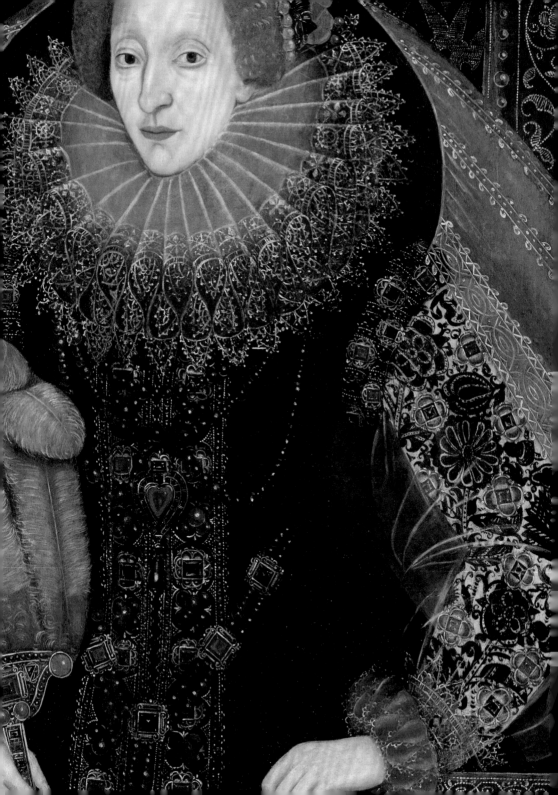

THE WATSON GORDON
LECTURE 2018

Heart's Desire:
The Darnley Jewel and
the Human Body

CYNTHIA HAHN

NATIONAL GALLERIES OF SCOTLAND
in association with
THE UNIVERSITY OF EDINBURGH

Published by the Trustees
of the National Galleries of Scotland, Edinburgh
in association with The University of Edinburgh
© The author and the Trustees of the National Galleries of Scotland, 2019

ISBN 978 1 911054 37 5

Frontispiece: Unknown artist, Queen Elizabeth I (fig. 20)

Designed and typeset in Adobe Arno by Dalrymple
Printed on Arctic G-Print
by Gomer, Wales

FOREWORD

The publication of this series of lectures has roots deep in the cultural history of Scotland's capital. The Watson Gordon Chair of Fine Art at the University of Edinburgh was approved in October 1872, when the University Court accepted the offer of Henry Watson and his sister Frances to endow a chair in memory of their brother Sir John Watson Gordon (1788–1864). Sir John, Edinburgh's most successful portrait painter in the decades following Sir Henry Raeburn's death, had a European reputation, and had also been President of the Royal Scottish Academy. Funds became available on Henry Watson's death in 1879, and the first incumbent, Gerard Baldwin Brown, took up his post the following year. Thus, as one of his successors, Giles Robertson, explained in his inaugural lecture of 1972, the Watson Gordon Professorship can 'fairly claim to be the senior full-time chair in the field of Fine Art in Britain'.

The annual Watson Gordon Lecture was established in 2006, following the 125th anniversary of the chair. We are most grateful for the generous and enlightened support of Robert Robertson and the R. & S.B. Clark Charitable Trust (E.C. Robertson Fund) for this series, which demonstrates the fruitful collaboration between the University of Edinburgh and the National Galleries of Scotland.

The thirteenth Watson Gordon lecture was given on 8 November 2018 by Cynthia Hahn, the distinguished Professor of Medieval Art at The Graduate Centre at the City University of New York (CUNY). Hahn's talk began with a close examination of the Darnley Jewel in the Royal Collection Trust at the Palace of Holyroodhouse, from which she pivoted to a wide-ranging examination of the importance of jewellery and its bodily associations, of family, love and affection, and of the tangibility of blood and relics. She drew together persuasive comparisons from objects held in collections throughout Edinburgh before bringing the lecture to a compelling close with a renewed look at the mysterious and beautiful Darnley Jewel.

DR HALLE O'NEAL
Director of Research, History of Art,
University of Edinburgh

SIR JOHN LEIGHTON
Director-General,
National Galleries of Scotland

[5]

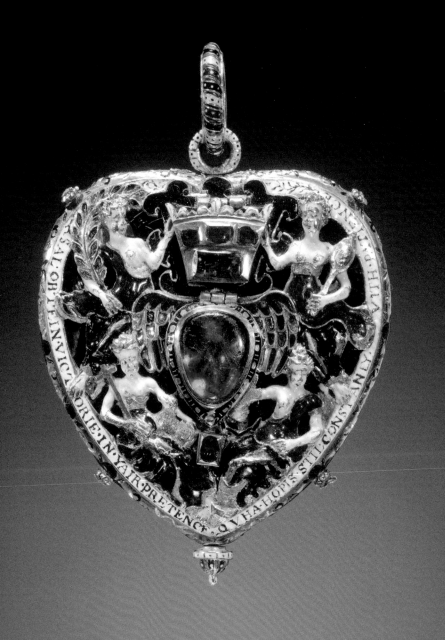

HEART'S DESIRE:
THE DARNLEY JEWEL AND THE
HUMAN BODY

'AND THOUGH SHE BE BUT LITTLE, SHE IS FIERCE.'[1]

One of the great but also tiny treasures of Edinburgh, the so-called Darnley or Lennox Jewel on display at the Palace of Holyroodhouse, remains a stubborn mystery (figs 1 and 16–19).[2] Commissioned by Lady Margaret Douglas, Countess of Lennox c.1571–78, in honour of her husband Matthew Stewart, Earl of Lennox and one-time Regent of Scotland, who fell in battle in 1571, it features a superabundance of images and sentiments. With such a perplexing combination of emblems and text – everything from family mottoes to challenges to maxims – it becomes impossible to decide if the jewel is a love token, a political gauntlet, or an object bespeaking family heritage. Without any possibility of fully resolving its mystery, I will argue that this heart is, in fact, all of these things. In discussing this complex object and considering the place of bodily adornment in mediaeval and early modern culture, it will become clear that its significance is far more than 'skin deep', penetrating to the very core of contemporary preoccupations. In this object, beginning with its very shape, we have no simple thing – the heart has a long and deep history, even dark and deep.

In the premodern era, the heart was not only at the centre of the body, but it also ruled the body. It was the location of memory, the soul and the emotions. But it also was the engine of the body but also the organ that directed the body. Before 1628 when the physician William Harvey wrote a theory of circulation and demoted it to the status of a mechanical pump, the heart was literally considered the source and origin of life's bright red blood distributed from the centre of the body to the limbs.[3] Indeed, the heart has been called the premier emblem of the mediaeval self.[4]

We begin with a notion of discovering the 'heart's desire', a project with no limitation given that in the Middle Ages and early modern period the heart could desire so many things. Not just the love of another, but even more passionately one

FIG.1 | UNKNOWN ARTIST
The Darnley Jewel or Lennox Jewel (front), c.1571–78
Gold, enamel, Burmese rubies, Indian emerald and cobalt-blue glass, 6.6 × 5.2 cm
(whole object). Royal Collection Trust.

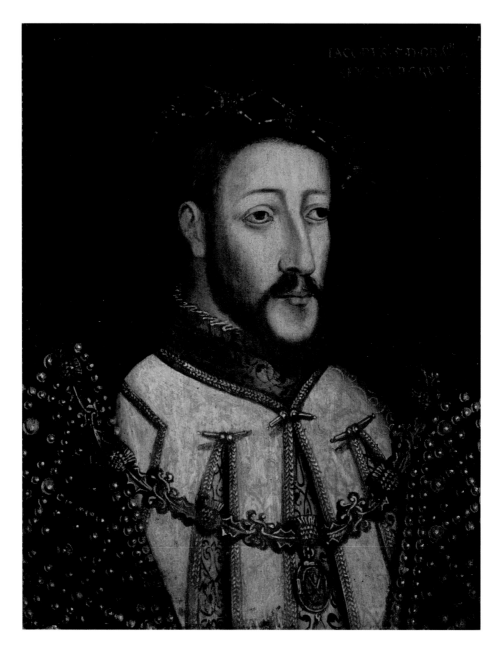

[8]

might desire God, or one's king. The king in turn might love his people and thereby sustain his nation. We will track the history of the heart as it was transformed from the vital organ at the centre of the body to a two-dimensional symbol and the ♥ note of today. Along the way, detours by way of jewellery and skin will reveal a potential for vectors of spiritual and moral change – the study of the heart is a more serious endeavour than one might perhaps have imagined.

Above all, objects such as the Darnley Jewel, although beautiful, are not to be dismissed as mere ornament. If we look to the portraits of the Tudors and the Stuarts, the main players at the time of the Jewel, we are struck by how very much jewellery they wore. Early mediaeval jewellery was worn discreetly, under clothing, but in this era of religious turmoil it seems to have been required to wear jewellery that proclaimed one's faith and status, as well as one's allegiance. Mary Queen of Scots was known for her lavish jewellery, as was her cousin Elizabeth (frontispiece, fig.25). Mary is always shown with a cross and a rosary, and modern historians have associated a large number of extant pieces with her or her circle (see figs.15 and 25).

But not only women wore jewellery. The ruling men of Scotland seem almost to have been required to wear collars representing their masculine power via their knighthood (figs 2–4).

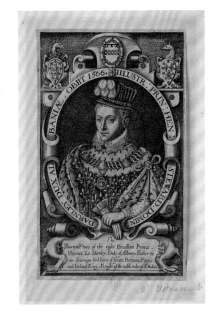

FIG.2 | UNKNOWN ARTIST
James V, 1512–1542. Father of Mary, Queen of Scots. Reigned 1513–1542, c.1579
Oil on panel, 41.3 × 33.0 cm. National Galleries of Scotland, Edinburgh.

FIG.3 | UNKNOWN ARTIST
Henry Stuart, Lord Darnley, 1545–1567. Consort of Mary, Queen of Scots, published 1618
Line engraving on paper, 11.1 × 8.6 cm. National Galleries of Scotland, Edinburgh.

[9]

FIG.4 | ADAM DE COLONE
*James VI and I, 1566–1625. King of Scotland 1567–1625. King of England and
Ireland 1603–1625,* after 1622
Oil on canvas, 109.3 × 89.5 cm. National Galleries of Scotland, Edinburgh.

That is, the collars of the orders of knighthood, each associated with one of the monarchies of Europe,[5] 'confirmed … status', along with '[other] brilliant clothing and bodily adornment'.[6] In a posthumous engraving, Lord Darnley (fig.3) as Mary's spouse can be seen wearing the French order of St Michael. James v (fig.2), again after death, is depicted proleptically graced with the Scottish Order of the Thistle, a late and intermittently appearing nationalist and originally Catholic ornament.[7] The Order of the Garter with its pendant emblem of George, although known as the chivalric order of England, was also often worn by Scots, including James i/vi (fig.4).

In addition to such jewellery with religious and political meaning, I want to emphasise that jewellery, then as now, had an emotional charge – and not only one concerning the tender emotions. Objects of personal adornment – things worn on the body, crosses, rosaries, precious gems, reliquaries, and sometimes other objects of sacred and talismanic power – represent a signal part of Christian material religion during the Middle Ages, and perhaps the most personally significant part of religious expression. This sort of material Christianity, although important for its heritage and memorial status, is above all a locus of identity as well as potential personal transformation and what one might call spiritual work. Béatrice Caseau writes eloquently about materials such as oil, water or cloth as media of transmission, especially in miracles.[8] To these significant substances, already so important in Biblical stories, should be added a consideration of the matter of which jewellery is made. Many of the most popular precious materials are believed to have had powerful and even transformative natures, attested already by the time of the Roman master of natural history, Pliny the Elder, in the first century AD.[9]

A few examples clarify what I am calling the transformative power of materials. Coral, called 'lithodendron' (see fig. 6), was thought to gain its power from its indeterminate place between earth and sea. As the oxymoronic 'stone plant', it was both natural *and* contrary to nature. Similarly, jet was believed not to burn, or to burn only when dosed with water. Mother-of-pearl had the power to birth a pearl, and the pearl itself was understood to be a marriage of heaven and earth. Rock crystal was hyper-frozen ice, in its nature linked to the heavens. Finally, gold, at the apex of the hierarchy of materials, represented incorruptibility.

In what is perhaps a more symbolic or mystical mode, Pliny particularly praised precious gems and even recommended gazing upon them for the revelations they hold about the natural world. Powerful men were instructed to collect them for the further power they could bestow,[10] and above all, they came from exotic locales. Tellingly, Renaissance settings left the gem open in the back so that its power could come into contact with the skin.[11] The blue stone on the Darnley Jewel, although now recognised as glass, was undoubtedly thought to be a precious, deep-blue sapphire, in a naturally occurring and uncut heart shape. Composed of such powerful stuff, jewellery is constituted by objects that focused desire, contemplation and aspiration. Jewels may have included figural representations, symbols and other images, but above all and persistently their materials carried profound significance.

Furthermore, jewels maintained their value and power, conveying it to subsequent owners. A duchess of the fourteenth century bequeathed a reliquary cross to her son in her will, calling it the 'thing of mine I have loved the best'.[12] In her touching sentiment, we detect two crucial features of wearable things, the aspects that make them so important to their owners: first, as both physical and persistent things, they are an essential part of a family heritage, treasured and passed down through multiple generations; second, as personal talismans and even reliquaries, they are somehow so affecting that they appeal to the truest and strongest emotions. They have both a physical and a spiritual nature; one could call it both body and soul.

At the other end of the spectrum from much of what we are discussing, a burial at St Helen's Fishergate in York (fig.5) indicates that, although the surviving evidence of bodily adornment is primarily aristocratic, it was not limited to the wealthy.[13] A much poorer Christian asked to be buried with the pilgrim's badge, the cockle shell, from her trip to Santiago de Compostela – not only as a sign of accomplishment and a token of her voyage, but also as a proclamation of her identity as a Christian.

In sum, jewellery in the Middle Ages and early modern period should be recognised as having a persistent yet transformative material nature that has a deeply personal and spiritual potential. Such objects both mark identity and provide a pathway to personal change. Indeed, although after the thirteenth century, as noted

above, people displayed much of their jewellery as riches on the exterior of their clothing, in the earlier Middle Ages, jewellery lay on the surface of the body. In this sense it takes the same status as skin and clothing. If the heart is the bodily seat of emotion, jewellery can represent a first focus on the exterior of the body, that in turn draws the mind inward. It will repay our attention to dive deep into these aspects of jewellery, body and spiritual potential in the Middle Ages before coming back to the Darnley Jewel, the Tudor era and hearts in general.

Nancy Caciola notes that at the moment of death, mediaeval 'bodies often are referred to as a sort of clothing in hagiographers' descriptions of spiritual dislocation: entering and exiting the body is like "putting on a tunic" or "shedding a garment"'.[14] In arguing that one must care for the bodies of the dead in *The City of God* (Book I, chapters 12–13), the great Father of the Church, Saint Augustine, compared the body to clothing but additionally invoked a favourite piece of jewellery, a ring, as an example of what a child might keep to remember his father. Augustine went on to insist that people wore their skin even more intimately than

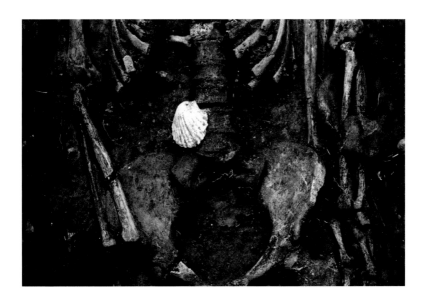

FIG.5
Female burial at St Helen's Fishergate, York, with pierced scallop shell.
Probably c.14th–15th century. Field Archaeology Specialists.

such material objects.[15] It is intriguing that this comparison should be made, that the boundary of the body is defined metaphorically as clothing and even as jewellery but also, of course, as skin. One must care for that skin and that body before and after death.

In his exegesis of the story of Adam and Eve, Augustine further pursues his discussion of skin, also considering its relationship to the heart and the eventual resurrection of the blessed:

God made for them garments of skin. That is, having abandoned the face of truth, they sought the pleasure of lying, and God changed their bodies into this mortal flesh in which deceitful hearts are hidden. … Rather as some states of soul are apparent on the countenance, and especially in the eyes, so I think that in the clarity and simplicity of those heavenly bodies absolutely no states of the soul are hidden. Men will merit that dwelling and transformation into angelic form if even in this life, when they could hide lies under the garments of skin.[16]

In evoking the animal-skin clothing that Adam and Eve put on to cover their shame, Augustine imagines them as an opaque covering over 'heavenly bodies' and therefore, in some sense, representative of skin. Skin thus not only constitutes the perimeter and definition of a human body, but also stands for its sinning nature. One of Augustine's emphases here becomes the possibilities of sight, or rather vision occluded by sin. We will find that looking inward – into the soul, the body, the heart – is a primary preoccupation throughout the Middle Ages, a spiritual endeavour that centres on hope for resurrection.

Finally, as Alexandra Pârvan observes, given that most philosophers and religious thinkers would argue that skin is essentially sinful and would even urge 'those who had fallen to strip off their material covering so as to undertake the ascension', it is notable that Augustine makes a particular exception. In considering Christ's incarnate body and his skin, he assigns that sacred corporeality the 'role of mediating our ascent to heaven, instead of interfering with it'.[17]

In sum, in the wake of Augustine's powerful exegesis, and as much more fully developed in later mediaeval thought and theology, Christ's skin takes a central role in salvation. It is conceived as originally pure and clear and without sin; only through suffering did it acquire disfiguring wounds, scars and darkness. Precisely

by means of Christ's incarnation, his taking on of body and skin, does his subsequent suffering and passion allow man's salvation. In consequence, in devotions of the later Middle Ages, Christians came to pursue a practice of studying Christ's Passion and his abused skin, subjecting themselves to pain and humiliation, and matching his suffering with their own so that, in turn, their souls could rise. In this way, over many centuries of devotion, the material nature of the skin, and I would argue of material things that adorn the skin, came to be central focal points for processes of faith.

The notion of the skin as an object of study is not, it should be noted, an invention of religious devotion. The great physicians of the ancient world, Galen and Hippocrates, were very attentive to skin. They describe the dermis as a permeable barrier (and for example, women in their role as mothers were especially permeable).[18] Evelyn Welch notes that 'the sixteenth-century physician Mercurialis described skin as a "fisherman's net", easily pierced and difficult to protect'.[19] Welch argues that mediaeval and Renaissance physicians learned to 'read' the skin for symptoms and diagnosis.

Virginia Langum finds a similar endeavour on the part of the mediaeval cleric's approach to confession. The priest would attempt to find evidence concerning the state of the Christian's soul by reading his or her 'complexion'. The complexion, in ancient and mediaeval sources, refers more generally to the condition of the body than to the skin, as Steven Connor argues,[20] but clearly the skin was a surface to be examined, as well as, of course, protected. Furthermore, although the body was surely permeable – witness the four purgations that could cleanse it: sweat, vomit, bloodletting and bitter drinks according to a fifteenth-century sermon[21] – dermal boundaries were also a useful barrier, one that had to be policed and preserved in order to maintain well-being during life, controlling what should enter and what should be excluded. In about 1400, Christine de Pizan made this a matter of virtue: 'one may understand that being virtuous is nothing other than having within oneself all the things that draw toward good, and draw outward and away all that is bad and full of vice'.[22] If one must defend one's body, monitor its borders to prevent the entrance of the bad and draw in the good, boundary markers serve the body well, and jewellery is one such marker.

[15]

In the Middle Ages and the early modern period, jewellery often functioned in just this way. Material body ornaments were named by a variety of Latin terms: *pendilia, monile* or *ligatura*.[23] These various terms share one notable quality. In addition to serving in inventories and other documents as names for types of jewellery or objects, they all concern how these precious personal objects related to the body: that is, they were hung, tied and bound, adhering to and binding the body, often for its protection.

I would also note that mediaeval and early modern crosses and other religious objects were often inscribed with protective textual formulae that circle issues of incarnation and Christ's birth. Some include text from the Gospel of John, or invocations of John the Baptist, or the Three Magi as 'names of power' that can only be called 'magical' in intent and speak to the recognition of Christ as both human and divine. Other things, people or formulae that were considered powerfully protective were the five wounds of Christ, prayers to the Virgin, and the *titulus* inscription (INRI) from the cross.[24] Red stones typically signified Christ's blood as foci of devotion but also as protection.

But I want to dig deeper, get even more intimate with this question of the power of skin. What about jewellery as adornment of the skin? How specifically is skin 'read'? How do marks or adornments on the skin reveal the soul and the interior of the Christian? And finally, and not at all least, where does the heart stand in all this?

Of course, some marks exist directly on the skin, as such sealed and marked. Tattoos were common in the Roman and early Christian world, and they were considered marks of shame, slavery or torture. The significance of these marks of shame was, however, reversed in their meaning by the Christian religion, especially in the stories of the martyrs. Saint Paul proudly claims to have a stigma, a mark of his Lord on his body (Galatians 6:17). Virginia Burrus argues that such stigmata can be seen as 'scarlike, a dense site – a deep surface – of complex and layered meaning, fusing (without quite confusing) rebellion and surrender, nobility and degradation, flesh and spirit, worldly and holy power'.[25] Already in the early Christian era, there can be a 'reading' of the dense surface of marks on the skin.

Burrus refers to a mark on the skin of Saint Macrina, sister of Saint Gregory of Nyssa, that is called both a sign and a stigma. The fourth-century text locates the

mark on her breast near the neck, and takes it to be evidence of the miraculous cure of 'an irremediable illness' that threatened to 'spread to places near the heart'. There was no surgery; instead, the spot of the swelling was rubbed with mud concocted with tears and healed by the imposition of a cross.[26] (Note: the saint also wore a cross as a pendant.) In hagiographic stories of the early Middle Ages, in similar gestures of healing and protection, Saint Margaret marked herself with a cross made with a hand gesture, and Saint Radegund even branded herself with a cross, leaving a scar.[27]

Perhaps the most spectacular example of such bodily marking occurred in 1224, and concerned the body of Saint Francis. During a vision in which Christ appeared to the saint at La Verna, Francis's hands, feet and chest were marked with wounds, and these marks again were termed stigmata. Although the saint carefully hid the marks throughout his life, when his body was examined at the time of his death Thomas of Celano reported:

> *it was wonderful to see amid his hands and feet not the prints of the nails but the nails themselves formed out of his flesh and retaining the blackness of iron, and his right side reddened with blood. The signs of martyrdom did not fill the minds of the beholders with horror but added much comeliness and grace.*[28]

Again, as a spiritual reversal, horrid wounds are here salvational. Francis's skin is materially transformed through Christ's imprint upon him, and notably, various materials are mentioned in the accounts of the saint's dead body. Celano mentions iron and the enduring red of fresh blood. In the authoritative biography of Francis titled *Legenda Maior*, written in the 1260s, Bonaventure initially describes the marks less graphically using the metaphor of wax impressed with a seal and 'likeness' of the 'Crucified'.[29] In yet another account, Saint Clare and her followers, in bidding Francis goodbye at his death, kissed 'his hands that glittered with precious gems and the most exquisite pearls'.[30] Although images of the stigmata of Francis rarely represent any material except blood,[31] in his San Bernadino altarpiece (1472–74), Piero della Francesca called attention to the meaning of the stigmata by depicting the saint holding a glowing rock crystal, gold and pearl cross aligned with his side wound (fig.6).[32]

Jewels and jewellery as metaphors of Christian devotion remain a persistent

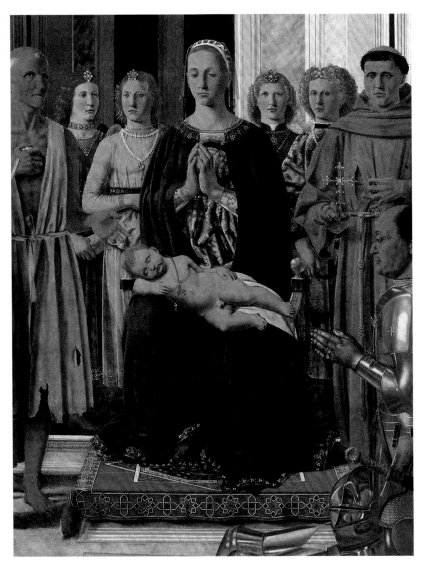

FIG.6 | PIERO DELLA FRANCESCA
*Madonna and Child with Saints, Angels and Federico da Montefeltro
(San Bernardino Altarpiece)*, 1472–74 (detail)
Tempera on panel, 251 × 172 cm. Pinacoteca di Brera, Milan.

motif in both texts and images throughout the Middle Ages and into the early modern period. The early Christian saint Margaret claimed to be sealed unto Christ and called the seal and her virginity 'a jewel'. Her name means 'pearl', which Jacobus de Voragine reminds us is 'small, white, and powerful' like the saint in her purity, humility and ability to do miracles.[33] In a vision, Saint Catherine of Siena (1347–1380) married the Christ child with a wedding ring, although according to Caroline Bynum, it was 'not the ring of gold and jewels that her biographer reports in his bowdlerized version, but the ring of Christ's foreskin'.[34] Mechtilde of Hackeborn (1240/1241–1298) also received a ring in a vision, studded with jewels representing Christ's love.[35]

In about 1340, Ambrogio Lorenzetti could imagine Mary Magdalene wearing a mystical, not quite substantial image of Christ upon her chest like a pendant, as confirmation of her dedication to Christ (fig.7, from a polyptych from the church of Santa Petronilla in Siena, now in that city's Pinacoteca; note the dissolving upper rim of the halo). The Magdalene's 'jewel' is strongly reminiscent of the Veronica icon, an image commonly worn in the form of a pilgrim's badge or reliquary pendant.[36] The Lorenzetti painting perfectly captures the sense of the permeable boundaries of the body, in this case a holy body, marked by devotion and the suffering of the Passion. Moreover, the image of Christ is centred over the Magdalene's heart, not only like a piece of jewellery but also like an 'image carried in the heart' – a literary trope common in love poetry but equally important to spiritual texts.[37] Perhaps the face of Christ here is even evocative of the Old Testament text of the Song of Songs (8:6–7): 'Set me as a seal on your heart'.

These varied examples speak to a wide range of possible marks, those made on the skin but also others made by way of jewellery. A more precise understanding of these ideas can come from a closer look at two holy figures: Saint Catherine of Siena, who so vividly linked jewellery and flesh with her 'invisible' wedding ring and other bodily marks; and the German mystic Henry Suso (1295–1366), whose self-inflicted scars, transformed into jewels, allowed him a vision into his own soul. The stories of these holy devotees demonstrate both that bodies and their ornaments could 'speak' and perhaps also that they could 'reveal' their truth as part of God's creation.[38]

Saint Catherine of Siena is quite literally given credit for testifying with her body and her skin in mediaeval texts. Ignoring in large part her written work, her biographer, Raymond of Capua, 'tried to describe the signs of the visionary, which were externally visible … Among these would have been a luminous face, her extraordinary behaviour, and the sounds emanating from her body'.[39] He also implied she was without education, even without words. Arguing for her sanctification, another supporter, Tommaso Caffarini, wrote extensively of Catherine's stigmata, and compared the marks to those of other saints (even illustrated in the marginalia of his text) in what was a veritable treatise on bodily marks.[40]

Associated with the Dominicans as a tertiary, but never herself a nun, Catherine had a particularly intimate relationship with Christ. In addition to her visionary marriage, in her devotions she matched her body to that of her Lord, using a flail to, in effect, duplicate his wounds. In illustrations of her life, both bodies are presented in parallel for inspection (fig.8).[41]

Above, we referenced Augustine's association of the skin with sin. In an even earlier tradition, that of the Greek of the New Testament Epistles, Paul speaks of the deeds of the flesh, or in Greek *sarx* (σάρξ), as a valuable sacrifice and juxtaposes flesh with body, that is, *soma* (σῶμα): 'For if ye live after the flesh, ye shall die: but if ye through the Spirit do mortify the deeds of the body, ye shall live'(Romans 8:13). Paul argues that one should chastise the flesh in order to achieve a Christian body: 'I chastise my body and bring it into subjection: lest perhaps when I have preached to others I myself should become a castaway' (1 Corinthians 9:27). Comparable to Catherine's performance, again Paul writes: 'In my flesh I complete what is lacking in Christ's afflictions, for the sake of his body, that is the Church' (Colossians 1:24). And finally, he locates the body as the place of glorification: 'therefore glorify God in your body', and 'so now also Christ shall be magnified in my body' (1 Corinthians 6:20 and Philippians 1:20). If the Christian achieved these goals of subjection of his/her body in glorification of God, at the moment of resurrection he or she would be judged as without sin: 'Yet now he hath reconciled in the body of his flesh through death, to present you holy and unspotted, and blameless before him' (Colossians 1:22).

That is, the Christian would match Christ's complexion in its perfection

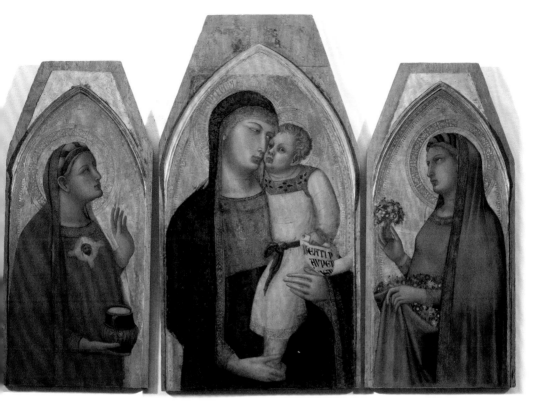

Madonna and Child with Saints Mary Magdalene and Dorothy, c.13th–14th century
Painting, medium and dimensions unknown. Pinacoteca Nazionale Siena.

– understood to be spotless, pure and white until he underwent torture. However, it should be noted that in the Biblical record, Christ himself also produces marks upon his skin, that is, he 'sweats blood' from his pores (Luke 22:44). According to ancient medical tradition, this condition would be an indication of weakness, impurity and lack of health: Aristotle argued that bloody sweat revealed an unfortunate natural condition of permeability and superfluity. Countering the negative cast of this understanding, the Franciscan John Pecham (in 1269) argued that Christ did not have any superfluity but rather that, in his case, the symptom evidenced 'the intensity of the experience of the heart's sadness, on account of which the blood is expanded by the great change and gathered around the heart and,

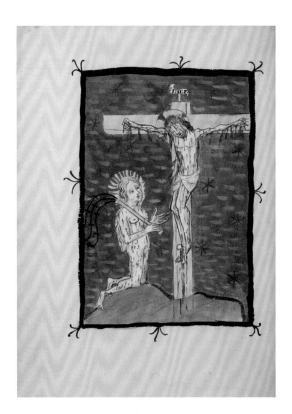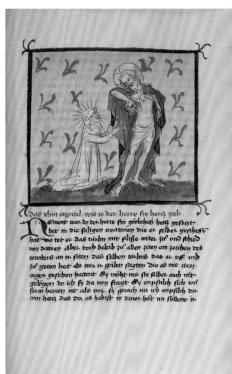

consequently, is dispersed through the members and expelled through the pores by the intensity of the heat'.[42] Thus, 'because of the power of his soul over the body and because of the nobility and delicacy or sensitivity of his complexion,'[43] he sweated blood for us. In the margin of a book of hours, a fifteenth-century image shows Christ's blood flowing so freely it is collected in a Eucharistic chalice (fig.10).[44]

Thus, to complete this reciprocity of bodies, the devout Christian, in turn, takes it upon him- or herself to mark his or her skin in imitation of the skin and suffering of Christ. The hope is that, at the time of judgement, these practices and this devotion will grant the devotee the spotless and even clear or shining body of the blessed. Albert the Great concluded that before sin 'man, among all creatures, more closely resembles a heavenly body owing to a balanced complexion'.[45] The Christian's goal is to achieve that complexion once again, to use the skin in this

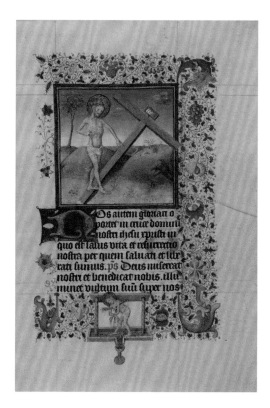

FIG.8 | RAIMOND DE CAPOUE
Life of St Catherine of Siena
Manuscript, 29.5 × 21 cm, 1401–
1500. Bibliothèque nationale de
France.

FIG.9 | RAIMOND DE CAPOUE
Life of St Catherine of Siena
Manuscript, 29.5 × 21 cm, 1401–
1500. Bibliothèque nationale de
France.

FIG.10 | UNKNOWN ARTIST
*Netherlands. Hours of
Catherine of Cleves*
Manuscript, 19.2 × 13 cm, *c.*1440.
The Morgan Library & Museum,
New York.

way as a path and means to resurrection, as Augustine specified. At Saint Francis's
death, in addition to wounds, there 'appeared in him in fact the form of the Cross
and Passion of the spotless Lamb Who washed away the sins of the world', and
he had flesh that glowed: 'And they beheld his flesh which had been dark before
glittering with exceeding whiteness and promising by its beauty the reward of a
blessed resurrection.'[46]

It is, however, a second image from Catherine's biography (fig.9) that shows
Christ awarding her perhaps the most significant and extraordinary prize for her
devotion – his own heart. In turning back to the heart, we turn to an organ of the
interior rather than the surface; but, as we will learn, the heart is capable of mov-
ing to the bodily surface and can be entirely visible in many instances, either in
metaphor or even in saintly reality. Before examining this startling image in detail,
a further discussion of the meaning of the heart will help bring it into focus.

Above all, the Christian heart is a place of memory. Eric Jager has traced the metaphor of 'writing on the heart' especially in the 'book of the heart' from the ancient world and the Bible, to the early Christian and ultimately the early modern period.[47] Notably, a series of Old Testament passages feature the notion of the inscribed heart, but also refer to phylacteries and talismans, and even engage with metaphors of materials and precious stones. From Deuteronomy 6:6: 'These words which I command you this day shall be upon your heart'; and from Proverbs 3:1–3: 'My son, do not forget my teaching, but let your heart keep my commandments … Bind them about your neck, write them on the tablet of your heart'. Finally, evil can also be written in the heart as in Jeremiah 17:1: sin 'is written with a pen of iron, with a point of diamond it is engraved on the tablet of their heart'.[48]

Jager argues that it was Augustine who, instead of working in metaphors, described a 'fleshly' heart and emphatically turned in his thinking to issues of interiority, privileging the heart in the *Confessions*.[49] The wounded heart, especially that torn by God's words and love (*caritas*), is figured with 'arrows fixed deep in our flesh', and appears at critical junctures in Augustine's own life story.[50] He seems to be the first to use the image of the heart as a positive force – in his case, his heart holds an image of God.[51] It would become an overwhelming desire in the Middle Ages to see into the heart – the hearts of others, one's own, or the heart of Christ.

As Catherine examines Christ's skin, and then in a later moment, his body (fig. 9), she focuses on his side wound and he obliges her desire to see into his body by drawing out his heart. This interaction is both a recurring feature in Catherine's visions and part of a sequence of events:

> [Christ] came to her, and opened her left side and took out and removed her heart, so that she remained without a heart inside … Another day … she was surrounded by a light from the sky, and in the light appeared the Lord, holding in his sacred hands a human heart, red and shining … The Lord opened her left side again. He put his own heart, which he held in his hands, inside her, saying, 'Here, dearest daughter, since I took away your heart before, now I bequeath to you my heart, so that you live forever.'[52]

This exchange of hearts, a motif in mediaeval love poetry and literature as early as the twelfth century in the stories of Chrétien de Troyes,[53] comes even to occur in actual

[24]

material practice – a seventeenth-century burial was recently discovered in which a widow is interred with her husband's heart enclosed in a heart-shaped capsule.[54]

Despite the familiarity of the conceit, Catherine is moved to ask Christ why he wanted to open his side and pour out his heart's blood, He instructs her in his answer: 'first of all, I wanted this because by having my side opened, I showed you the secret of my heart. For my heart held more love for humankind than any eternal physical act could show.'[55] Beginning with Bernard of Clairvaux in the twelfth century, devotional imagery pictured Christ's side wound as reaching to and revealing the heart. This and other pictorial imagery represents Christ's side wound as 'framing' a view of the heart.[56]

Even earlier than Catherine, Saint Lutgarde of Aywières (d.1246) exchanged hearts with Christ in visions.[57] Saint Gertrude of Helfta (1256–1302), casting herself as bride of Christ in the mode of the Old Testament's Song of Songs, had already asked Christ to 'Stamp my heart with the seal of your heart' … and 'open to me the innermost recesses of your heart' … and 'may your love carry my heart into you … my soul loves you, my heart desires you, my virtue cherishes you.'[58] Notwithstanding the model of love that Lutgarde, Gertrude and Catherine supply as vivid models of mystic devotion via their bodies and hearts, an even more compelling image of unrestrained devotion to Christ occurs in the life of a male mystic who, in order to dedicate himself to Christ, aggressively carved and mutilated the flesh over his heart.

Henry Suso, born in 1295 near Constance, devoted his life to contemplation and teaching as part of the Dominican order. He is known for his visionary experiences and strenuous devotional practices, many recorded in the *Exemplar*, an illustrated copy of which is now in Strasbourg.[59] The *Exemplar* records a remarkable incident that began when one day Suso felt a 'fire' in his heart indicative of love as well as suffering. He opined, 'gentle God, if only I could think of a sign of love between you and me, that no forgetting could erase.'[60] Here Suso sought something permanent, something transformative, a deep bodily connection to Christ. Suso's answer to his own question was to take up a stylus and engrave, or in fact *gouge*, into his chest the letters IHC – the monogram of Christ (more commonly written IHS). As the *Exemplar* details, he used vigorous stabbing motions and produced

FIG.11 | UNKNOWN ARTIST
page from Life of Blessed Henry Suso, 1300
Parchment with half-binding in calfskin, 21 × 17 cm. National and University Library of Strasbourg.

FIG.12 | UNKNOWN ARTIST
page from Life of Blessed Henry Suso, 1300
Parchment with half-binding in calfskin, 21 × 17 cm. National and University Library of Strasbourg.

FIG.13 | UNKNOWN ARTIST
page from Life of Blessed Henry Suso, 1300
Parchment with half-binding in calfskin, 21 × 17 cm. National and University Library of Strasbourg.

profuse bleeding. Suso then prayed before a crucifix and asked for the sign also to be imprinted *inside* his body, asking Christ to 'press yourself further into the ground of my heart'. This *topos* of the engraved heart is familiar. As we have seen, it signifies memory, and it could also represent eternal promises or the acquisition of profound knowledge.[61] Suso's physical performance of the *topos* is striking in its vivid enactment upon his flesh and even on the flesh/parchment of the page (fig.11). Suso created a scar and wore it until his death, a dramatic mark with each stroke as 'thick … as a blade of grass', 'and as often as his heart beat, the name moved'.[62]

The story takes yet another fascinating turn, visionary in nature. After praying matins, Suso sat in the chair in which he normally meditated, put a book of the Desert Fathers under his head, and 'drifted away' into not a nap but a visionary state:

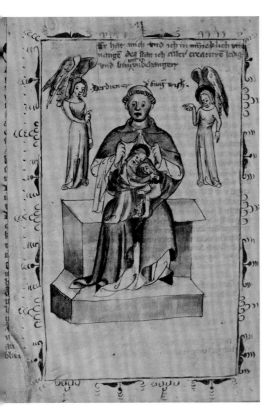
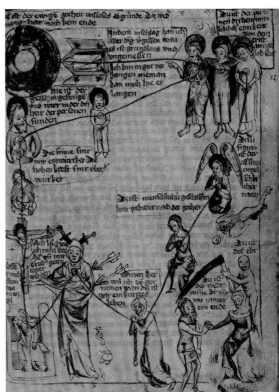

some kind of light flooded out of his heart, and he looked toward it. There on his heart appeared a golden cross into which many precious jewels had been skillfully inlaid. These sparkled beautifully … [He covered it] but nothing could diminish its powerful beauty.[63]

The artisanal and material reference of the text – 'a golden cross into which many precious jewels had been skillfully inlaid' – is striking. Materiality and even jewellery finds a prominent place in Suso's spiritual and visionary world.

In yet other visions, Suso hears music or dances, or the 'dew of divine grace descends into his soul'.[64] All his visions were multi-sensory, but above all, they allowed him to examine and study his heart and soul. In another that again evokes the materiality of precious gems, Suso embraces Holy Wisdom (fig.12). Angels often visited him during his visions, and in this instance he was instructed by them

to 'look with joy into yourself and see how dear God plays his games of love with your affectionate soul'. He saw 'that over his heart his body was as clear as crystal, and he saw in the middle of his heart eternal Wisdom sitting quietly with a pleasing appearance … his soul was pressed to [God's] divine heart'.[65] In other words, Suso looked into his own heart.

In following the example of her master, the nun Elspeth Stagel had her own revelation. She did not herself experience a miracle or a bodily mark; rather, in imitation of the marks on Suso's body, she begins 'secretly' to wear an image of the monogram of Christ, embroidered on red silk, and then to reproduce and disseminate such patches to other women, after first asking Suso to touch them to his chest. Elspeth notably wears her token next to her heart, directly upon her skin.[66]

Finally, one last and central image in the *Exemplar*, Suso's life, speaks to the juncture of the interior and exterior image, the heart's truth and its revelation to the world through God's nature. In explaining the form of the Trinity to Elspeth, Suso describes an emblem-like object that is illustrated in the manuscript as a nested set of circles (fig.13, see especially upper left). It is the Trinity, he explains, as formless abyss. In his discussion of the presence of the Trinity in the world, Suso writes: 'think of the form of a man. Out of the innermost depths of his heart there springs forth this same form in such a way that it gazes back upon itself.'[67]

Suso further imagines this mirror-like form as literally allowing one to look into one's body via mystical contemplation. The illustration pictures the emblem as a disc hovering over the chest of each of the figures, connected by a red line, 'a brilliant radiance … [that] shines back and floods the sightless intellect with unknown invisible dazzling lights'.[68] Now instead of the skin obscuring truth, one might look past the sinful barrier.

Suso even expresses a certain presence and physicality in his description of his vision, noting that one might 'press into the circle'. In response, perhaps, to this directive it should be remarked that the illustration in the Strasbourg manuscript is exceptionally worn. The image is tarnished and darkened silver, but has also been touched so often that much of the silver is gone. As an emblem of potential yet frustrated sight (or perhaps visionary blindness), the disc might be compared to the dark glass or mirror of 1 Corinthians 13:12, a text that promises clear vision only

after death: 'now we see through a glass darkly; but then face to face'.[69] In the illus-
trations, the disc is placed always over the heart, and it is no surprise that it looks
like a pendant. This vision reifies the overwhelming desire of mediaeval devotees
and mystics to see into the body, to see past the skin and into the heart, in order to
correct and purify themselves, to see truth, and ultimately to see the divine.

The desire to see into the heart, especially the saintly heart, was so intensified
by such mystical visionary literature that it might even be said to have led to one
of the earliest recorded 'autopsies' of the Middle Ages. Saint Clare of Montefalco
(1268–1308) had visions in which she spoke to Christ, and in one of these he gave
her his cross to hold in her heart. After her death, the sisters of the monastery
investigated, and eagerly opening her body 'they were moved to cleave and see her
heart and viscera'.[70] They dissected the body and found not only a cross but also
a set of Passion instruments constructed of her flesh inside her heart, but also as
other objects, notably three (Trinitarian) stones in her gall bladder.[71] The heart
is still venerated as a relic in the Basilica of Saint Clare in Montefalco in Umbria.

An afterlife of these visionary texts and bodies of the thirteenth and four-
teenth centuries persists both in texts and in objects. German sixteenth-century
nuns depict their hearts as houses, tidy and ready to welcome Christ.[72] Spanish
seventeenth-century conventual literature uses similar metaphors of interiority
in picturing the lives of women who were not renowned mystics. Stories describe
nuns 'eating' gems and, in one instance, a 'precious diamond' was said to reside
within a holy woman's soul in a golden coffer to which Christ alone had the key.
(Diamonds begin to replace rock crystal in the early modern period as the most
valuable gem.) Such interior gems are even imagined to illuminate the soul like an
interior star. In the case of Blessed Mary Catherine of St Augustine, a seventeenth-
century canoness of Quebec, light is said to have shone from her open mouth.[73]
In some sense these interior gems represent the hidden virtues of cloistered nuns,
but for Christians in the world, material gems and ornaments proclaimed personal
devotion and took up the work of spiritual devotion. The IHC or IHS monogram
is an important part of such continuing devotion and appears on brooches and
pendants – for example, a rock crystal heart which would have been worn over
the heart (fig.14).

[29]

So at last we ask: how can this knowledge of Christian hearts and metaphors of interiority clarify our understanding of the Darnley heart and English jewellery of the second half of the sixteenth century? Rather than referencing the heart of Christ and its well-developed imagery and meaning in the Christian Middle Ages, the Darnley heart, although clearly full of its own aching desire, remains primarily a political heart. Even if it is not overtly taking part in a religious meaning, however, I would argue that here political meanings derive from Christian ones. Christian belief established the heart as of central importance, not only for its still-rising significance in Christian devotion (the Feast of the Sacred Heart was instituted only in 1886), but also as the very foundation of Christian rule. The political heart, in effect, finds its origin in the divine heart.

Before going any further, it would be useful to reacquaint ourselves with the main cast of characters in the era of the production of the Darnley Jewel as well as to review its imagery. Notable players in the Scottish drama include: Margaret, who commissioned the heart in honour of her husband Matthew Stewart; their son Darnley (fig.3), who married Mary Queen of Scots (who was of course Queen Elizabeth's cousin) (fig.15); and the fruit of that union, the future King James VI of Scotland, named James I of England after Elizabeth's death (fig.4).

The Darnley heart is covered with complex imagery, much of it difficult to interpret. The reverse of the heart clearly concerns itself with family declarations and the hope for progeny (fig.16). The heart motif itself, in the familiar symmetrical and pointed form that became popular just before 1400,[74] was in fact one of the heraldic devices of the Douglas family.[75] Another part of Douglas heraldry on the reverse is the salamander. Care of and for family is additionally expressed by the phoenix which rises from the ashes, and especially the pelican that will sacrifice herself for her children. Finally, what looks

FIG.14 | UNKNOWN ARTIST
Pendant, early 17th century
Rock crystal and enamelled gold, 7.2 × 5.5 × 1.9 cm. Victoria and Albert Museum, London.

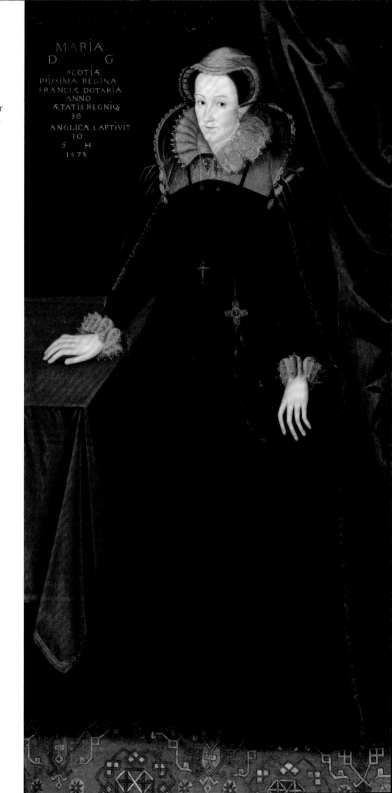

FIG.15 | UNKNOWN ARTIST
Mary, Queen of Scots 1542–1587, Reigned 1542–1567, c.1610–15
Oil on canvas, 201.5 × 95.7 cm.
National Galleries of Scotland, Edinburgh.

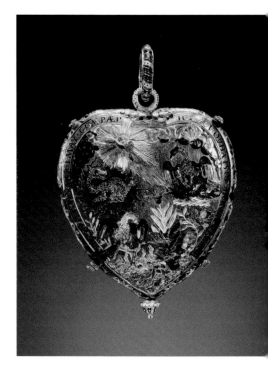

like a golden thistle but is usually identified as a sunflower springs from the loins of
a man, presumably a promise of children.

A number of aspirations are expressed in the mottoes and statements on the
heart. Again on the back, in sixteenth-century Scots, is the declaration: 'MY STAIT
TO YIR I MAY COMPAER FOR ZOV QVHA IS OF BONTES RAIR' (My state to these
I may compare for you who are of rare goodness). On the front of the tablet,[76] an
unusual construction includes two little doors that reveal what might be construed
as secretive messages. Under the blue glass heart (fig.18) we read: 'DEATHE SAL
DESOLVE' (Death shall dissolve), with image of a skull, a horn and linked hands,
presumably a message that represents a marital vow to be pursued until death. In
the other compartment under the rubies and emerald of the crown (fig.17), we see
the monogram MSL, for Margaret/Matthew Stewart Lennox, combined with an
image of two hearts, shot through with arrows but bound as one with a belt and a
love knot; the inscription reads: 'QUAT WE RESOLV' (What we resolve).[77]

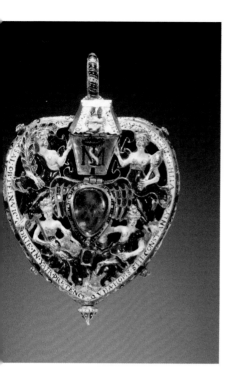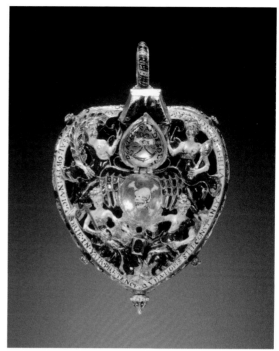

Finally, on the interior of the tablet, a series of emblematic scenes centre on time, fortune, both good and bad, as well as martial imagery (fig.19). I must call upon sixteenth-century experts to untangle these complex images, undoubtedly based on emblem books. It has been suggested that they have something to do with the travails of Mary Douglas or even those of the Queen of Scots; they are certainly political in nature.

What seems, however, most significant in understanding the heart is the phoenix-like repetition of the winged heart on the front with the 'sapphire' at its breast and the emerald-and-ruby-encrusted crown as its head (see fig.1); the figure is supported by Faith and Hope, Victory and Truth. The inscription: 'QVHA. HOPIS. STIL. CONSTANLY. VITH. PATIENCE. SAL. OBTEIN. VICTORIE. IN. YAIR. PRETENCE' (Who hopes still constantly with patience shall obtain victory in their claim) seems to clearly support Darnley royal ambitions. In contrast with the secret and fleshy hearts under the crown, this is an imagery of the heart as

[33]

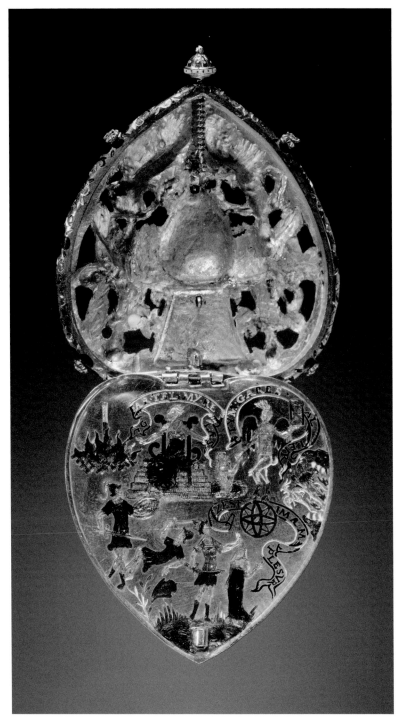

FIG.19 | UNKNOWN ARTIST
The Darnley Jewel or Lenno
Jewel (inside), c.1571–78
Gold, enamel, Burmese rubies,
Indian emerald and cobalt-blue
glass, 6.6 × 5.2 cm (whole object
Royal Collection Trust.

something strong and indomitable and even heavenly in its cerulean colour. Not a devotional heart, not a love heart – what sort of heart is this?

Other aspects of the heart, not yet discussed, come to the fore in understanding this apparition. In this era, the heart was not only the centre of the body but also the centre of the 'body politic'. The common metaphor of the nation as body, ruled by its head, is modified in the late mediaeval period to refocus on the heart. A French political tract, the *Avis aus roys*, made perhaps for Louis VI about 1347–50 and now in the Morgan Library, New York, represents the heart as the seat of wisdom and good counsel (fig.21). In origin, this notion is Biblical – Proverbs 21:1 asserts that the king's heart is ultimately controlled by God: 'The king's heart is in the hand of the LORD, as the rivers of water: he turneth it whithersoever he will.' In the political understanding of the late Middle Ages, the heart of a king is not primarily corporeal, but rather is an ideal thing that supersedes mere human flesh. In perhaps her most famous self-assessment, Queen Elizabeth I addressed her physical weakness as a woman, yet claimed 'I have the heart and stomach of a king.' These blatantly fleshly organs somehow stand for a special and abstract body that supersedes carnality.

Indeed, it was these very organs, the heart and the viscera, removed in burial in a long-standing French and English tradition often copied in other countries, that stood for the spirit of kingship and valour.[78] The bodies of French kings were buried at Saint-Denis, their hearts in other churches of special import to the sovereigns.[79] The custom found its way to Scotland as well. Famously, on his deathbed, Robert the Bruce asked for his heart to be carried to the Holy Land to fulfil his vow to go on Crusade. It was eventually buried separately from his body in Melrose abbey.[80]

Elizabeth I of England, as above, was well aware of the power of the heart, and in one portrait the queen is depicted with a heart pendant, apparently a ruby, amplified by rows of diamonds along with sombre black pearls – called Queen's pearls because so very valuable and large (fig.20 and frontispiece). An elegy written shortly after her death noted that she who had been born on the eve of the Feast of the Nativity had died on the eve of the Feast of the Annunciation, and that she was the second among women because 'Mary bore God in her womb, but Elizabeth bore God in her heart.'[81]

In political theory, primarily originating in France, the heart came to be a key

point of discussion. It might be ceded that the Pope was the head of the Church, but in granting the king absolute power, French writers emphasised that the heart, as the source of blood, was the more important and independent organ and could direct the limbs and the rest of the body.[82]

The image of the body politic in the Morgan Library copy of the *Avis aus roys*, a sort of 'mirror for princes', develops the place of the heart in a series of passages and illustrations. In one, the king, much like Saint Catherine, gives his heart to Christ (fig.22). But unlike Catherine, royal concerns do not primarily turn inward. Instead the king gestures outward to encompass his nation and his subjects, who are sheltered behind him under his cloak like suppliants to a Madonna of Mercy.[83] The king wants to follow Christ's will, and he promises that his heart will be directed by God, as in the Proverbs text. The concept joins faith and good rulership, which together empower the king to act, sometimes even on his own judgement, outside the Church. Shakespeare has Henry VI say 'My crown is in my heart, not on my head.'[84]

Before we leave the *Avis aus roys*, I would note that many other images in the Morgan Library manuscript feature hearts: one shows the king as 'magnanimous', giving a heart; and others show his knights bearing heart-shaped shields. One last image centres a solar blaze over the royal heart, demonstrating once again that it is the king's *body* that emanates strength and power (from Prudence), not his head. Turisanus, a French doctor at the University of Paris at the beginning of the fourteenth century, argued that 'just as the sun is the source of light, the heart is the source of spirit, and … the sun is the universal origin of life in the world'.[85] Ultimately, this imagery understands the king's heart in a cosmic environment, literally at the centre of the universe.

Although I have begun with a French manuscript, similar ideas most certainly reached the British Isles. In a copy of the short book *Les abus du monde*, now in the Morgan Library, made for James IV of Scotland about 1510, we again encounter an image of the king's heart, but this one is disembodied (fig.23). The original text, written by Pierre Gringore, was offered to Louis XII of France. The *Abus du monde* spends a great deal of time opining on the poor state of the world, but offers up the heart of the king as a gift from God and a means to control rampant

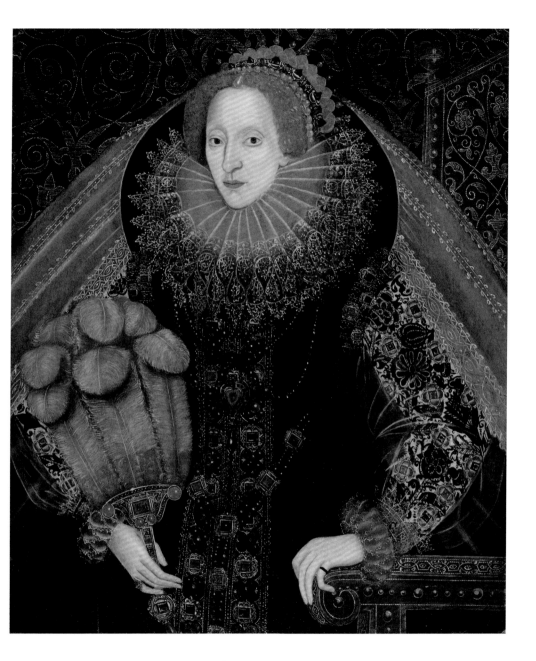

FIG.20 | UNKNOWN ARTIST
Queen Elizabeth I, 1585–90
Oil on panel, 95.3 × 81.9 cm. National Portrait Gallery, London.

violence. In the miniature in the copy of the French text made for a Scottish king, the royal heart is offered by the hand of God, gloriously crowned and circled by the jewelled collar of the order of the archangel Michael.[86] Clearly, it is not associated with a particular body, but it is ready and valorous and magnificent (draped with jewels!).

In turning back to the portrait of Elizabeth, I would argue that she does not wear the heart jewel as a display of devotion. There is no doubt she was devout and not averse to making a show of it – she is known to have continued to pray to a crucifix, to have touched people to heal scrofula, and to have washed the feet of the poor in the Maundy Thursday ceremony.[87] Nevertheless, Elizabeth 'held' God in her heart (as represented by the jewel positioned over her heart) because that was in her nature as sovereign. Hers was not the weak and small body of a woman, but an alternative one, the virginal and pure and strong body of a king/queen. She styled herself quite literally as an embodiment of the mediaeval legal understanding of the king's two bodies: one was the body politic; one, the living corporeal body; but in her person both were joined. Just as contemporary political theory talked of the love the good king had for his subjects which was the origin of all that was good and just in royal behaviour, Elizabeth often and loudly proclaimed her love for her subjects.[88]

[38]

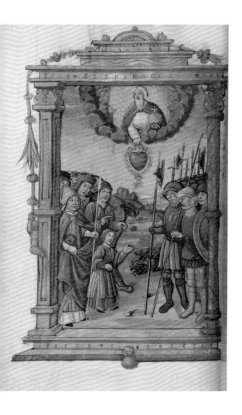

Although Elizabeth's jewellery use is often characterised as a personal indulgence, it is surely just one more carefully deployed strategy to demonstrate her power as a sovereign. Her chosen sign, the phoenix – the virgin and female bird which reproduced without a man, rising in fire from the ashes – is featured as a prominent jewel in a painting now in the National Portrait Gallery in London (fig.24).[89] In the portrait, she wears this sign on her breast as part of a collar ensemble that looks very much like a stand-in for the chivalric collars and orders of knighthood discussed above. It is both massive and hangs low on the shoulders. The white pearls and black diamonds were chosen to indicate her chastity as the colours symbolic of virginity; the fiery red ruby crosses and phoenix spoke to the power of her heart. If Elizabeth was said to dress in doublets that imitated those of men, it was not the only way she magnified her body. She made strategic use of heraldic cloaks and the glory of many gems in order to create the magnificence due a monarch.[90] Rather than a womanly love of gems as often implied, her attention to collars echoes her father's reported love for them.[91] As glittering and magnificent objects, 'Crown jewels' and their like established the power and glory of the State.

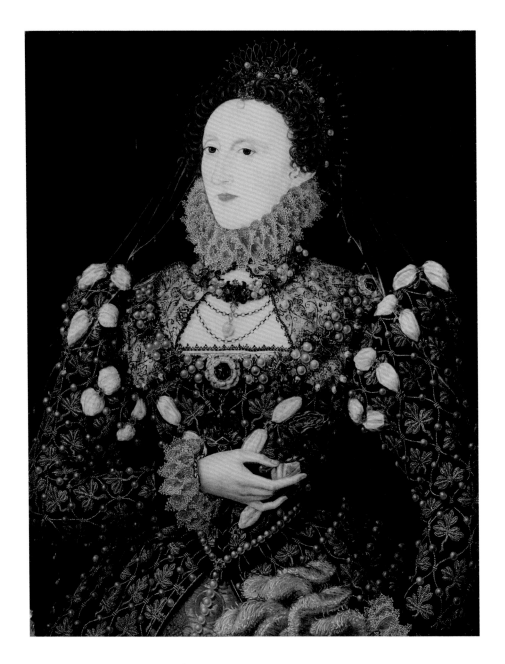

FIG.24 | ASSOCIATED WITH NICHOLAS HILLIARD
Queen Elizabeth I, c.1575
Oil on panel, 78.7 × 61 cm. National Portrait Gallery, London.

Indeed, scholars argue that Elizabeth repeatedly used pieces of jewellery as a powerful but intimate political tool. She disseminated lockets with images of herself for others to wear, her portrait encased as a gem. Some of these objects were even likened by contemporaries to reliquaries; perhaps some held a lock of hair.[92] Precious miniature portraits not only mimic Christian icons and reliquaries, but also echo the function of badges worn by French courtiers, or again the collars worn by knights of orders. That is, all these objects show the allegiance as well as the love that binds sovereign and subject. The Fettercairn Jewel, now missing its miniature, may have had a similar use.[93] We know that symbolic and politically meaningful jewels were given to Elizabeth as gifts and she gave them in return.[94]

Finally, to complete our circle, we return to Scotland. Just like Elizabeth, Mary Queen of Scots used jewels as powerful markers of identity and as a means to bind her subjects to her. Having lived in the French court, Mary was familiar with the popular use of portrait miniatures set as jewels in France, and came to be famous for disseminating images of herself among those dedicated to her.[95] We end with one very lovely example, covered with intricate enamels and with a cameo of Mary

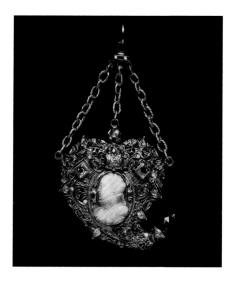

FIG.25 | UNKNOWN ARTIST
Locket depicting Mary, Queen of Scots, late 16th century
Gold, enamel and onyx, 5.1 × 2.2 cm (cameo). National Museums of Scotland, Edinburgh.

at the centre. It is once again shaped as a heart and reveals yet another dimension of that organ (fig.25). Anatomists claimed that the heart 'leaned' within the body, in particular that the bottom bent to the right. The subtle distortion of the classic heart shape on this pendant seems to evidence a physiological notion of the heart's role in heating the body. That is, the lower portion was thought to function as a sort of exhaust pipe. This jewel, not entirely conforming to the anatomical heart, starts with the classic symmetrical shape but then twists to the right and is exuberantly capped with a terminal ruby. Perhaps the dark red-purple stone is intended to appear like a drop of blood, evidencing the heat and suffering of Mary's particular heart as she was deposed and imprisoned.[96]

Ultimately, it is clear that such heart jewels are not general symbols of love, or even unequivocal badges of allegiance. Instead, they are perhaps best understood as solemn promises. Already the *Avis aus roys* recommended the love of the sovereign as superior to armed force. In a country such as England, the success and order of rule of a nation 'without a standing army or extensive police force'[97] was better represented by love and loyalty than by force. Hearts worn by the sovereign promised adherence to the principles of love of people; hearts worn by the people in turn promised love of their ruler.

At last we return to the Darnley heart, and we must recognise that it is so much more than a love token from Lady Darnley to her husband. One might even suggest that Lady Darnley would have been wary of such a simple token of affection – earlier in her life she was imprisoned twice for love matches that were not approved by the king. Rather, Lady Darnley does make a bold move with her commission, but it is one that is bigger than a gesture of affection. Given that the jewel might have been produced after her husband's death, this small but fierce object seems to be a vow to her husband. Until they were joined in death, she promised to fight for their shared heart's desire – the fulfilment of the family line in achieving royal status. As the phoenix rose from the ashes, her family survived censure and banishment, ill fortune and even murder, until finally their wish came true. Margaret Douglas's grandson, a Darnley, a Lennox, Mary Stuart's child, acceded to the Scottish throne and finally – as James I – became Elizabeth's successor, as king of England.

NOTES & REFERENCES

1. Shakespeare, *A Midsummer Night's Dream*, Act 3, scene 2.
2. It is described as being of 'Gold, enamel (émail en ronde bosse, émail basse-taille), Burmese rubies, Indian emerald and cobalt-blue glass | 6.6 x 5.2 cm (whole object) | RCIN 28181': Somers-Cock 1980, pp.38 and 57–58 (at which time it was still believed the blue 'stone' was a sapphire).
3. Webb 2010; Healy 2018 discusses the political implications of Harvey's publications, especially in light of his own royalist sympathies.
4. Jager 2001.
5. Boulton 2000.
6. McCall 2013, p.446.
7. There are sixteenth-century comments about the 'Knights of St Andrew', and the imagery of the Thistle appeared in heraldic contexts, but the formal order of knighthood was not established until 1687 by James VII: see Matikkala 2008, pp.77–81, and Shaw & Burtchaell 1906, p.vii.
8. Caseau 2017.
9. Pliny the Elder; and Hahn 2018, pp.21–35.
10. Lightbown 1992, pp.37 and 202–8.
11. Scarisbrick 1995, p.51.
12. The will is that of the Duchess of Gloucester in 1399: Lightbown 1992, p.203.
13. Gilchrist 2008, fig.2.
14. Caciola 2017, p.209.
15. Augustine of Hippo 1887.
16. Augustine of Hippo 1991, p.127: *Against the Manichees*, Book II, chapters 21 and 32.
17. Pârvan 2012, p.65.
18. Connor 2004, p.21.
19. Welch 2017.
20. Connor 2004, p.15.
21. Langum 2013, p.145.
22. Akbari 2013, p.292.
23. Lightbown 1992.
24. Skemer 2006, pp.84–87; Lightbown 1992, p.99. AGLA was a common protective inscription standing for the Hebrew words *atha gebri leilan adonai* (Thou art mighty forever, O Lord).
25. Burrus 2003, p.405.
26. Ibid.
27. McNamara *et al.* 1992, p.81; and 'Margaret', in Voragine 2012, p.369.
28. Thomas of Celano 1926, Book 9, para.113.
29. Bonaventure 1904, Prol.2; Didi-Huberman 1999, pp.64–74.
30. *An Umbrian Choir Legend (1253–59)*, translated in Armstrong *et al.* 1999, p.476.
31. Although Bonaventure also discusses the nails: 'the heads of the nails shewing in the palms

of the hands, and upper side of the feet, and their points shewing on the other side; the heads of the nails were round and black in the hands and feet, while the points were long, bent, and as it were turned back, being formed, of the flesh itself, and protruding therefrom': Bonaventure 1904, 13.3. I thank Claudia Bolgia for discussing this with me.

32. The angels of this altarpiece also wear striking celestial gems and jewellery. See information on the website of the Pinacoteca di Brera: https://pinacoteca-brera.org/en/collezione-online/opere/the-virgin-with-child-angels-and-saints/.

33. Voragine 2012, p.368.

34. Bynum 1987, p.246.

35. Hamburger 1997, pp.134–35.

36. A pilgrim wears a Veronica badge on his hat as depicted on a Cologne altarpiece (Hahn 2018, p.124) as well as other later pendants and badges (pp.131–39). There are also examples in the Victoria and Albert Museum: M.95-1962, C. 1500, http://collections.vam.ac.uk/item/O15223/pendant-unknown/.

37. Discussed in Meneghetti 2005; for the image see Bagnoli et al. 2017.

38. Langum 2013 discusses Augustine's frustration with the language of the body (p.143).

39. Böse 2013, p.216; Ganz 2013.

40. For Caffarini see Moerer 2005.

41. Paris, BnF, MS allemand 34, Convent Schönensteinbach (?) (Dominicans) Southern Middle-Alsace c.1420. fols 4v. and 54r. See Webb 2010 and Webb 2018.

42. Resnick 2013, p.177.

43. Ibid., p.178.

44. *Christ in the Winepress*, Netherlands, c.1440, detail from the Book of Hours of Catherine of Cleves (MS M.917/945), p.121, Morgan Library and Museum, New York, online at https://www.themorgan.org/collection/hours-of-catherine-of-cleves/75.

45. Resnick 2013, p.179.

46. Thomas of Celano 1926, chapter 9, para.112.

47. Jager 2001.

48. Finally, Gregory the Great uses the trope in *Pastoral Care*, but now about 'pictured imagery' and in a cautionary sense: 'when the images of external things are drawn into consciousness, what is revolved in the mind by thinking in pictured imagery is, as it were, portrayed on the heart': Gregory the Great 1895, Book II, chapter 10.

49. Jager 2001, pp.27–43.

50. Ibid., p.33, citing Conf 9:2. Here the wounds are in the heart and viscera.

51. Jager 2001, p.37.

52. Translation from Webb 2010, p.137. Latin in Raymond of Capua 1863, p.907.

53. Yalom 2018, pp.59–68. For the exploration of the idea in Chaucer – Troilus ultimately finds the exchange of hearts with a lover unsatisfactory and gives his heart to Christ – see Clark & Wasserman 1984.

54. 'The heart of Toussaint de Perrien, Knight of Brefeillac, was sealed in a lead container after his death in 1649 and eventually buried with the body of his wife Louise de Quengo, who died seven years later': https://news.nationalgeographic.com/2017/02/france-embalmed-heart-rennes-quengo-perrien-archaeology/.

55. Catherine of Siena 1988, p.254.

56. *Book of Hours*, Paris, BN Lat 1369, p.410, c.1500.

57. Merton 1948, preface and chapter 2.

58. Gertrude the Great 1989, pp.33, 35, 38, 40, 48, 68 and 74; and Suso 1989, pp.7, 81 and 91.

59. Strasbourg, Bibliothèque Nationale et Universitaire, MS 2929 is the earliest

illustrated manuscript, *c.*1365–70, although there are three others. See Falque 2017, appendix. For the Strasbourg manuscript, see Colledge & Marler 1984 and the library website https://bvmm.irht.cnrs.fr/consult/consult.php?reproductionId=17064.

60. Suso 1989, p.70.

61. Learning is writing on the heart, as in the Golden Legend version of the Life of Ignatius of Antioch – Jager 2001, pp.91 and 98.

62. Suso 1989, p.71.

63. Ibid.

64. Ibid., p.74.

65. Ibid., p.73. For an understanding of Suso's use of the image, see Falque 2017. She concludes that although Suso has no confidence in imagery, he wants to use it as a 'dynamic' tool. Also essential are Hamburger 1989 and Hamburger 1998.

66. Suso 1989, pp.172–73. Hamburger comments on this 'circulation' of images and gives examples of other similar gifts of small images and their devotional use on the body: Hamburger 1998, pp.263 and 266. Also, Hamburger 2007.

67. Suso 1989, p.201.

68. Ibid., p.200.

69. Hamburger 2000, p.364.

70. Park 2006, p.47.

71. Park 2006 gives a number of interesting examples: for Chiara, see chapter 2. Elena was said to be without a heart, having given it to Christ. This was confirmed in part by dissection (pp.151–52). Saints could even get a kind of transfusion of blood, determined at autopsy (Saint Columba, p.171). And their skin could be examined by doctors for symptoms (p.172).

72. Hamburger 1997.

73. These stories of nuns and the canoness come from Roullet 2015.

74. For the shape of the heart, see Grzybkowski 2000.

75. Added in honour of James Douglas's service to the Bruce: see below and n.80. Hulme 1892, p.12.

76. This is not a locket but a popular form of jewellery in the Renaissance: Scarisbrick 1995, p.84. Is it a coincidence that one speaks of the 'tablet of the heart'? – Jager 2001, pp.10, 11 and 21.

77. Of course, arrows could be shot by Cupid but also occur in religious imagery: Jager 2001, p.33.

78. Bande 2009.

79. Ibid.; Hallam 1982; Warntjes 2012; Weiss-Krejci 2010.

80. Given that he had made a vow of pilgrimage, Robert the Bruce asked Sir James Douglas to carry his heart to the Holy Land. When Douglas fell in battle in Spain, both were returned to Scotland and buried at Melrose Abbey. This is often given as an explanation of the use of the heart as a device by the Douglas family. See Penman 2013, p.1039, and Warntjes 2012, pp.230–32.

81. Levin 2013, p.30.

82. 'Dans l'optique de défendre les prétentions du roi face à la papauté, les théoriciens du pouvoir royal adoptent une perspective concentrique et font du prince le coeur de la communauté, transformant l'organe en outil de propagande monarchique … "Item le cuer est la partie principal qui envoye a un chascun membre vie et esmeuvement selon ce qu'il ha plus grant necessité a tout le corps […] quar le cuer distribue a un chascun membre ce qui li appartient (I, 21)33" … Ce discours entérinant la supériorité du coeur sur la tête – justifiant par là même l'indépendance du pouvoir temporel': Lepot 2013, p.279. See also Lepot 2012.

83. Scordia 2011, pp.45–57. In Gilles of Rome, love of God is first for the King: in *Amors*, 'bons princes doit avoir en li verai charité, c'est a dire amer Dieu de tout sonc cuer et de toute sa vertus surs et devant toutes autres choses et son prochain comme li mesmes' (I, 16) – Lepot 2013, p.281.

84. *King Henry VI*, Part 3, act 3, scene 1.

85. 'l'esprit sort du coeur, comme la lumière du soleil. En effet, de même que le soleil est la source de la lumière, le coeur l'est de l'esprit, et de même que le soleil est le principe de la génération et de la corruption, universellement à l'origine de la vie dans le monde par son mouvement et sa lumière, ainsi le coeur est dans l'animal le principe de vie par son mouvement' – Lepot 2013, p.289; citing Torrigiano 1557, fol.35r, as quoted by Jacquart 1998, p.362.

86. Morgan MS M 42, *Les abus du monde*, Rouen, France, *c*.1510, https://www.themorgan. org/manuscript/76877.

87. Levin 2013, pp.17 and 32–35.

88. Ibid., pp.9 and 68.

89. For a discussion of this panel NPG 190, see https://www.npg.org.uk/research/ programmes/making-art-in-tudor-britain/ the-phoenix-and-the-pelican-two-portraits-of-elizabeth-i-c.1575.php.

90. A theme in Somers-Cock 1980, p.37.

91. Scarisbrick 1995, p.75.

92. Hackenbrock 1979, pp.270–72.

93. Gold, enamel, almandine garnet, *c*.1560–80, National Museum of Scotland, X.2017.45, https://www.nms.ac.uk/fettercairnjewel.

94. Somers-Cock 1980, pp.38–40.

95. Scarisbrick 1995, pp.30 and 62–66. Compare the example of the Lyte Jewel given by James I: Awais-Dean 2017, pp.19–20. Also the Penicuik jewels: https://edinburgh. org/101?objid=8136#object75.

96. Gold, enamel, onyx, diamonds, ruby, with a portrait of Mary. National Galleries Scotland, H.NF 33, https://www.nms.ac.uk/ explore-our-collections/collection-search-results/?item_id=20074. Avicenna in his *Canon of Medicine* combined Aristotle and Galen. He believed 'that the heart produced breath, the "vital power or innate heat" within the body; it was an intelligent organ that controlled and directed all others': https://web.stanford.edu/class/history13/ earlysciencelab/body/heartpages/heart. html. Also, Leonardo da Vinci believed the heart exhaled with heat: Atkinson 1964; and Webb 2010, p.92.

97. Levin 2013, p.24.

BIBLIOGRAPHY

AKBARI 2013

Suzanne Conklin Akbari, 'Death as meta-morphosis in the devotional and political allegory of Christine de Pizan', in *The Ends of the Body: Identity and Community in Medieval Culture*, ed. S.C. Akbari and J. Ross, Toronto, 2013, pp.283–313

ARMSTRONG ET AL. 1999

Regis J. Armstrong, J.A. Wayne Hellmann and William J. Short (ed.), *Francis of Assisi – The Founder: Early Documents*, Vol.2, New York, 1999: online at https://www.franciscantradition.org/francis-of-assisi-early-documents/the-founder

ATKINSON 1964

M.H. Atkinson, 'Man's changing concept of the heart and circulation', *Canadian Medical Association Journal*, vol.91, 1964, pp.596–601

AUGUSTINE OF HIPPO 1887

Augustine of Hippo, 'City of God', trans. Marcus Dods, in *Nicene and Post-Nicene Fathers, First Series, Vol.2*, ed. Philip Schaff, Buffalo, New York, 1887 (revised and edited for New Advent by Kevin Knight: online at http://www.newadvent.org/fathers/1201.htm)

AUGUSTINE OF HIPPO 1991

Augustine of Hippo, *Saint Augustine – On Genesis: Two Books on Genesis Against the Manichees and On the Literal Interpretation of Genesis: An*

Unfinished Book, ed. S.J. Teske, Washington, DC, 1991

AWAIS-DEAN 2017

Natasha Awais-Dean, *Bejewelled: Men and Jewellery in Tudor and Jacobean England*, London, 2017

BAGNOLI ET AL. 2017

Alessandro Bagnoli, Roberto Bartalini and Max Seidel (ed.), *Ambrogio Lorenzetti (Siena, 22 ottobre 2017 – 21 gennaio 2018)*, exh. cat., Milan, 2017

BANDE 2009

Alexandre Bande, *Le cœur du roi: les Capétiens et les sépultures multiples, XIIIe-XVe siècles*, Paris, 2009

BONAVENTURE 1904

Bonaventure, *The Life of Saint Francis of Assisi*, trans. E. Gurney Salter, New York, 1904: online at https://www.ecatholic2000.com/bonaventure/assisi/francis.shtml

BÖSE 2013

Kristin Böse, '"Uff daz man daz unsicher von dem sichren bekenen mug": the evidence of visions in the illustrated "Vitae" of Catherine of Siena', in *Catherine of Siena: The Creation of a Cult*, ed. Jeffrey F. Hamburger and Gabriela Signori, Turnhout, 2013, pp.215–37

BOULTON 2000

D'Arcy Jonathan Dacre Boulton, *The Knights of the*

Crown: The Monarchical Orders of Knighthood in Later Medieval Europe, 1325–1520, Woodbridge, 2000

BURRUS 2003
Virginia Burrus, 'Macrina's Tattoo', *Journal of Medieval and Early Modern Studies*, vol.33, 2003, pp.403–17

BYNUM 1987
Caroline W. Bynum, *Holy Feast and Holy Fast: The Religious Significance of Food to Medieval Women*, Berkeley, California, 1987

CACIOLA 2017
Nancy M. Caciola, *Afterlives: The Return of the Dead in the Middle Ages*, Ithaca, New York, 2017

CASEAU 2017
Béatrice Caseau, 'Byzantine Christianity and tactile piety, fourth to fifteenth centuries', in *Knowing Bodies, Passionate Souls: Sense Perceptions in Byzantium*, ed. Susan Ashbrook Harvey and Margaret Mullett, Boston, Massachusetts, 2017, pp.209–22

CATHERINE OF SIENA 1988
Letters of Catherine of Siena, trans. Suzanne Noffke, Binghamton, New York, 1988

CLARK & WASSERMAN 1984
S.L. Clark and Julian N. Wasserman, 'The heart in "Troilus and Criseyde": the eye of the breast, the mirror of the mind, the jewel in its setting', *The Chaucer Review*, vol.18, 1984, pp.316–28

COLLEDGE & MARLER 1984
Edmund Colledge and J. C. Marler, '"Mystical" pictures in the Suso Exemplar MS Strasbourg 2929', *Archivum fratrum praedicatorum*, vol.54, 1984, pp.293–354

CONNOR 2004
Steven Connor, *The Book of Skin*, Ithaca, New York, 2004

DIDI-HUBERMAN 1999
Georges Didi-Huberman, 'Wax flesh, vicious circles', in *Encyclopaedia Anatomica*, ed. Monika von Düring *et al.*, Cologne, 1999, pp.64–74

FALQUE 2017
Ingrid Falque, '"Daz man bild mit bilde us tribe": imagery and knowledge of God in Henry Suso's Exemplar', *Speculum*, vol.92, no.2, 2017, pp.447–92

GANZ 2013
David Ganz, 'The dilemma of a saint's portrait: Catherine's stigmata between invisible body trace and visible pictorial sign', in *Catherine of Siena: The Creation of a Cult*, ed. Jeffrey F. Hamburger and Gabriela Signori, Turnhout, 2013, pp.239–62

GERTRUDE THE GREAT 1989
Gertrude the Great of Helfta: Spiritual Exercises, trans. Gertrude Jaron Lewis and Jack Lewis, Kalamazoo, Michigan, 1989

GILCHRIST 2008
Roberta Gilchrist, 'Magic for the dead? The archaeology of magic in later medieval burials', *Medieval Archaeology*, vol.52, 2008, pp.119–59

GREGORY THE GREAT 1895
Gregory the Great, 'Pastoral care', ed. James Barmby, in *Nicene and Post-Nicene Fathers, Second Series*, vol.12, ed. Philip Schaff and Henry Wace, Buffalo, New York, 1895 (revised and edited for New Advent by Kevin Knight: online at http://www.newadvent.org/fathers/36011.htm)

GRZYBKOWSKI 2000
A. Grzybkowski, 'Herzbilder in der Kunst des 13.–14. Jh. zwischen Erotik und Mystik', *Arte medievale*, vol.14, 2000, pp.101–12

HACKENBROCK 1979
Yvonne Hackenbrock, *Renaissance Jewellery*, London, 1979

HAHN 2018
Cynthia J. Hahn, with contributions by Anna Beatriz Chadour-Sampson and Sandra Hindman, *The Thing of Mine I Have Loved the Best: Meaningful Jewels*, Paris, 2018

HALLAM 1982
Elizabeth M. Hallam, 'Royal burial and the cult of kingship in France and England, 1060–1330', *Journal of Medieval History*, vol.8, 1982, pp.359–80

HAMBURGER 1989
Jeffrey F. Hamburger, 'The use of images in the pastoral care of nuns: the case of Heinrich Suso and the Dominicans', *Art Bulletin*, vol.71, no.1, 1989, pp.20–46

HAMBURGER 1997
Jeffrey F. Hamburger, *Nuns as Artists: The Visual Culture of a Medieval Convent*, Berkeley, California, 1997

HAMBURGER 1998
Jeffrey F. Hamburger, 'Medieval self-fashioning: authorship, authority, and autobiography in Suso's Exemplar', in *The Visual and the Visionary: Art and Female Spirituality in Late Medieval Germany*, New York, 1998, pp.233–78

HAMBURGER 2000
Jeffrey F. Hamburger, 'Speculations on speculation: vision and perception in the theory and practice of mystical devotion', in idem *Deutsche Mystik im abendländischen Zusammenhang. Kolloquium Kloster Fischingen, 1998*, ed. W. Haug and W. Schneider-Lastin, Tübingen, 2000, pp.353–408

HAMBURGER 2007
Jeffrey F. Hamburger, 'Visible yet secret: images as signs of friendship in Seuse', *Oxford German Studies*, vol.36, 2007, pp.141–62

HEALY 2018
Margaret Healy, 'Was the heart "dethroned"?: Harvey's discoveries and the politics of blood, heart, and circulation', in *Blood Matters: Studies in European Literature and Thought, 1400–1700*, ed. B. L. Johnson and E. Decamp, Philadelphia, 2018, pp.15–30

HULME 1892
F.E. Hulme, *The History, Principles and Practice of Heraldry*, London, 1892

JACQUART 1998
D. Jacquart, *La médecine médiévale dans le cadre parisien*, Paris, 1998

JAGER 2001
Eric Jager, *The Book of the Heart*, Chicago, 2001

LANGUM 2013
Virginia Langum, 'Discerning skin: complexion, surgery and language in medieval confession', in *Reading Skin: Essays in Medieval Literature and Culture*, ed. Katie Walter, London, 2013, pp.141–60

LEPOT 2012
Julien Lepot, 'Le prince justicier dans l'Avis aus roys', in *Le roi fontaine de justice: pouvoir justicier et pouvoir royal*, ed. Silvère Menegaldo, Paris, 2012, pp.193–207

LEPOT 2013
Julien Lepot, 'Le cœur équivoque dans l'Avis aus roys: un "miroir des princes" du XIVe siècle', *Cahiers de recherches médiévales et humanistes*, vol.26, 2013, pp.273–94

LEVIN 2013
Carole Levin, *The Heart and Stomach of a King: Elizabeth I and the Politics of Sex and Power*, Philadelphia, 2013

LIGHTBOWN 1992
R.W. Lightbown, *Mediaeval European Jewellery: With a Catalogue of the Collection in the Victoria & Albert Museum*, London, 1992

MATIKKALA 2008
Antti Matikkala, *The Orders of Knighthood and the Formation of the British Honours System, 1660–1760*, Woodbridge, 2008

MCCALL 2013
Timothy McCall, 'Brilliant bodies: material culture and the adornment of men in North Italy's Quattrocento Courts', *I Tatti Studies in the Italian Renaissance*, vol.16, 2013, pp.445–90

MCNAMARA ET AL. 1992
Jo Ann McNamara, John E. Halborg and E. Gordon Whatley (ed. and trans.), *Sainted Women of the Dark Ages*, Durham, North Carolina, 1992

MENEGHETTI 2005
Maria Luisa Meneghetti, 'Il ritratto in cuore: peripezie di un tema medievale tra il profano e il sacro', in *Riscritture del testo medievale: dialogo tra culture e tradizioni: atti del convegno, Bergamo 14–15.11.2003*, Bergamo, 2005, pp.73–86

MERTON 1948
Thomas Merton, *What are These Wounds? The Life of a Cistercian Mystic, Saint Lutgarde of Aywières*, Dublin, 1948

MOERER 2005
Emily A. Moerer, 'The visual hagiography of a stigmatic saint: drawings of Catherine of Siena in the "Libellus de Supplemento"', *Gesta*, vol.44, 2005, pp.89–102

PARK 2006
Katharine Park, *Secrets of Women: Gender, Generation, and the Origins of Human Dissection*, New York, 2006

PÂRVAN 2012
Alexandra Pârvan, 'Genesis 1–3: Augustine and Origen on the "coats of skins"', *Vigiliae Christianae*, vol.66, 2012, pp.56–92

PENMAN 2013
Michael Penman, '"Sacred food for the soul": in search of the devotions to saints of Robert Bruce, King of Scotland, 1306–1329', *Speculum*, vol.88, 2013, pp.1035–62

PLINY THE ELDER
Pliny the Elder, *The Natural History*, ed. John Bostock: online at http://www.perseus.tufts.edu/hopper/text?doc=Plin.+Nat.+toc

RAYMOND OF CAPUA 1863
Raymond of Capua, *Legenda maior*, in *Acta sanctorum ... editio novissima*, ed. J. Carnandet *et al.*, Paris, 1863

RESNICK 2013
Irven Resnick, 'Luke 22.44 and sweating blood: Jesus and medieval natural philosophers', *Viator*, vol.44, 2013, pp.169–88

ROULLET 2015
Antoine Roullet, *Corps et pénitence: les carmélites déchaussées espagnoles (ca 1560–ca 1640)*, Madrid, 2015

SCARISBRICK 1995
Diana Scarisbrick, *Tudor and Jacobean Jewellery*, London, 1995

SCORDIA 2011
Lydwine Scordia, 'Concepts et registres de l'amour du roi dans le De regimine principum de Gilles de Rome', in *Amour et désamour du prince, du Haut Moyen Âge à la révolution française*, ed. Josiane Barbier, Monique Cottret and Lydwine Scordia, Paris, 2011, pp.45–57

SHAW & BURTCHAELL 1906
William Arthur Shaw and George Dames Burtchaell, *The Knights of England: A Complete Record from the Earliest Time to the Present Day of the Knights of All the Orders of Chivalry in England, Scotland, and Ireland, and of Knights Bachelors,*

Incorporating a Complete List of Knights Bachelors Dubbed in Ireland, London, 1906

SKEMER 2006
Don C. Skemer, *Binding Words: Textual Amulets in the Middle Ages*, University Park, Pennsylvania, 2006

SOMERS-COCK 1980
Anna Somers-Cock, *Princely Magnificence: Court Jewels of the Renaissance, 1500–1630*, London, 1980

SUSO 1989
Henry Suso: The Exemplar, with Two German Sermons, ed. Frank Tobin, New York, 1989 (for the German original: Henry Suso, *Heinrich Seuse, Deutsche Schriften: Im Auftrag der Württembergischen Kommission für Landesgeschichte*, ed. Karl Bihlmeyer, Stuttgart, 1907; repr. 1961).

THOMAS OF CELANO 1926
Thomas of Celano, *First Life of Saint Francis*, trans. A.G. Ferrers, in M.L. Cameron, *The Inquiring Pilgrim's Guide to Assisi*, London, 1926: online at http://www.indiana.edu/%7Edmdhist/francis. htm#2.9

TORRIGIANO 1557
Pietro Torrigiano, *Plusquam commentum*, Venice, 1557

VORAGINE 2012
Jacobus de Voragine, *The Golden Legend: Readings on the Saints*, trans. William Granger Ryan, Princeton, New Jersey, 2012

WARNTJES 2012
Immo Warntjes, 'Programmatic double burial (body and heart) of the European high nobility *c*.1200–1400', in *Death at Court*, ed. Karl-Heinz Spiess and Immo Warntjes, Wiesbaden, 2012, pp.197–259

WEBB 2010
Heather Webb, *The Medieval Heart*, New Haven, Connecticut, 2010

WEBB 2018
Heather Webb, '"The lake of my heart": blood, containment, and the boundaries of the person in the writing of Dante and Catherine of Siena', in *Blood Matters: Studies in European Literature and Thought, 1400–1700*, ed. B.L. Johnson and E. Decamp, Philadelphia, 2018, pp.31–42

WEISS-KREJCI 2010
Estella Weiss-Krejci, 'Heart burial in medieval and early post-medieval Central Europe', in *Body Parts and Bodies Whole*, ed. Katharina Rebay-Salisbury, Marie Louise Stig Sørensen and Jessica Hughes, Oxford, 2010, pp.119–34

WELCH 2017
Evelyn Welch, 'CFP: The porous body in Renaissance Europe', 11 April 2017: online at https://effacedblog.wordpress.com/2017/04/11/ cfp-the-porous-body-in-renaissance-europe/

YALOM 2018
Marilyn Yalom, *The Amorous Heart: An Unconventional History of Love*, New York, 2018

ACKNOWLEDGEMENTS

Thanks are due to many, many people who have engaged with me on this project but here I name only a few. First, of course, thanks to Mr Robert Robertson, and to the National Galleries of Scotland, for granting me the honour of delivering this lecture. I further acknowledge a substantial debt to the Institute for Advanced Study in Princeton and a membership in 2017–18 where I had the time to explore the topic. Sandra Hindman of Les Enluminures drew me into the study of jewellery and its fascinating complexity – involving people, meanings and materials. Halle O'Neal, Heather Pulliam and Claudia Bolgia, as well as students and other faculty of the History of Art department of the University of Edinburgh, made my stay in Scotland a delight. I am grateful to the National Galleries of Scotland staff who worked hard to bring this publication into reality. Finally, I dedicate the volume to my son, Theodore Lockwood, who recently discovered that jewellery might serve a very special role in his life.